RICHARD ARTSCHWAGER

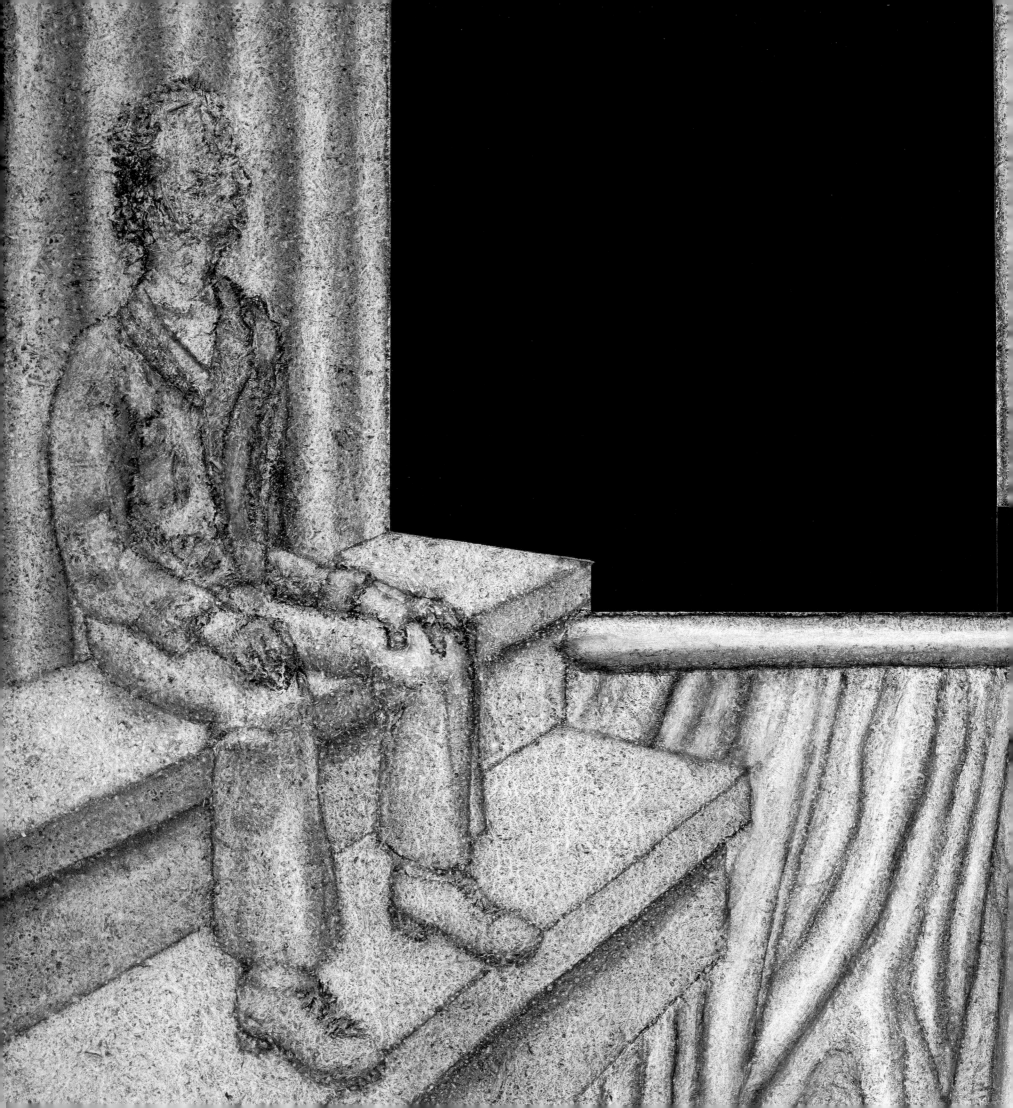

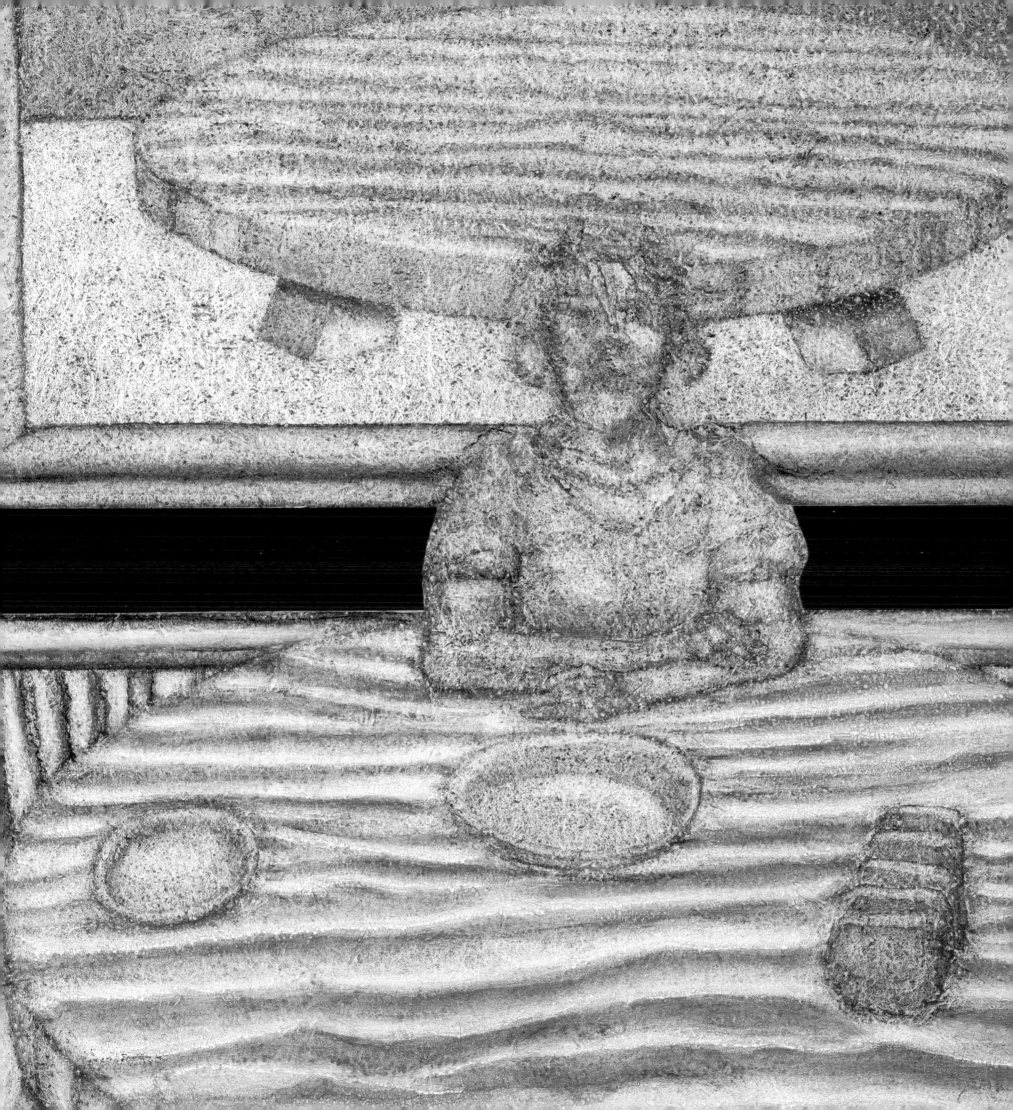

A Connoisseur of Absurdities [1]
John Yau

fig. 1
Richard Artschwager
Handle I
1962
Wood
47 ¼ x 28 inches
120 x 71 cm

Richard Artschwager is an American original who will never be seen as a mainstream artist. Speaking in 1992, he said (in reference to his longtime friend Malcolm Morley, but the statement is equally true of his own work): "Originality in art usually comes about by doing some damn fool thing and then finding it to be not so dumb. Or in any case by pushing the matter of editing and connoisseurship as far into the future as possible." [2] Other artists may have sustained the same degree of experimentation throughout their careers—Lee Bontecou and Peter Saul, in particular, come to mind—but none has experimented as extensively when it comes to materials. Artschwager's undeniable—and, to my mind, unique—strength is the bond he manages to efficiently effect between highly unlikely materials (Formica, Celotex, rubberized horsehair, acrylic bristle, extremely rough-surfaced handmade paper) and banal subject matter (furniture, images of suburban houses, high rises, office desks, domestic interiors, still lifes, landscapes).

In this regard, Artschwager clearly learned something from Jasper Johns, but he never turned that lesson into a bid for mainstream acceptance, as did Frank Stella and Andy Warhol. His engagement with perception and other philosophical and aesthetic issues distinguishes Artschwager from Stella and Warhol; he has never made work where, as Stella once famously said, "what you see is what you see." [3] Though his work has been included in innumerable group shows devoted to Minimalism and Pop art, it never fits in; it is secure within its own impenetrable space and needs no rubric to justify its existence. That is because Artschwager's subversions come from a deeper place than the desire to collapse art historical categories or to comment on art, and the paradoxes in his work aren't social comments, but metaphysical insights. It is why the art world doesn't quite know what to do with him; his intention is too serious for a scene looking for the next exemplar of male adolescence or overblown intellect (think smartass). The zone Artschwager's work brings you to isn't predicated on entertainment and hipster cynicism, but on the willingness to contemplate one's relation to ordinary reality and mortality.

Artschwager was around forty when he began making works such as *Handle I* (1962, fig. 1), a sculpture the viewer can physically grasp and presumably carry off, thus being both inside and outside the frame at the same time. About his early work, Artschwager wrote: "The art I make takes place about one step away from the normal stir of human activity." [4] The area contained within this ever-changing and immeasurable distance is just one of the many variables that Artschwager has explored throughout his career. Rather than become mired in a single solution, Artschwager has kept moving. An inimitable maverick from the beginning, and showing no sign of letting up, he has always gone his own way, quietly and rigorously hewing to his own standards, which include a commitment to craftsmanship, the use of improbable materials, the subversion of conformist avant-garde thinking regarding painting's opticality and sculpture's inert physical presence, and, as his recent work makes palpable, the exploration of subject matter many consider obsolete.

It is both inspiring and remarkable that at the age of eighty-five, Artschwager can still look at the world with fresh, open eyes and feelings of tenderness and affection. There is no sign of retreat into a doctrine of any kind and the false securities it would provide. All of this comes through in his recent paintings and sculptures. Consider *Table (Whatever)* and *Table (Somewhat)* (pages 41 and 43), sculptures that revisit *Table with Pink Tablecloth* (1964, fig. 2). A table is a place to talk and eat, a site of communality and its opposite, isolation. Set with a "pink tablecloth" made of Formica on wood, Artschwager's early table is actually a solid rectangular object at which no one could comfortably sit and eat. Consequently, it conveys the inevitability of absence. His formally set table is, among other things, a memorial for a dinner that will never be served, a reminder of what lies in store for all of us.

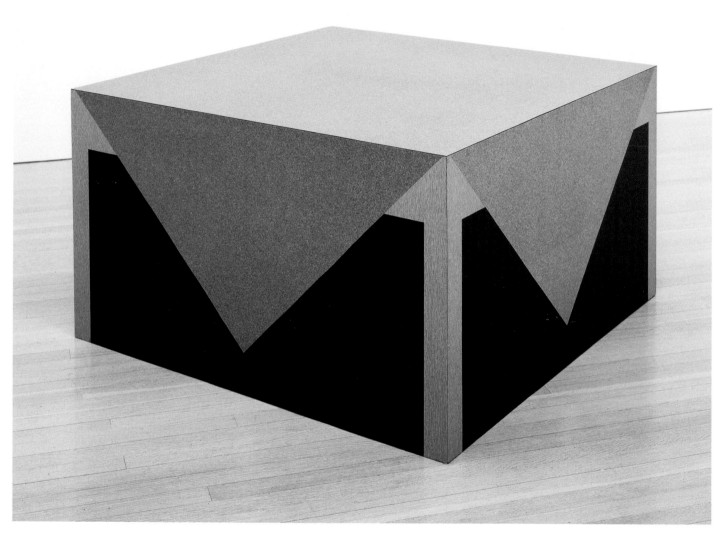

fig. 2
Richard Artschwager
Table with Pink Tablecloth
1964
Formica on wood
25 ½ x 44 x 44 inches
65 x 112 x 112 cm

fig. 3
Giorgio Morandi
Still Life
1919
Oil on canvas
23 x 24 inches
59 x 60 cm
Pinacoteca di Brera, Milan
Bequest of Emilio and Maria Jesi

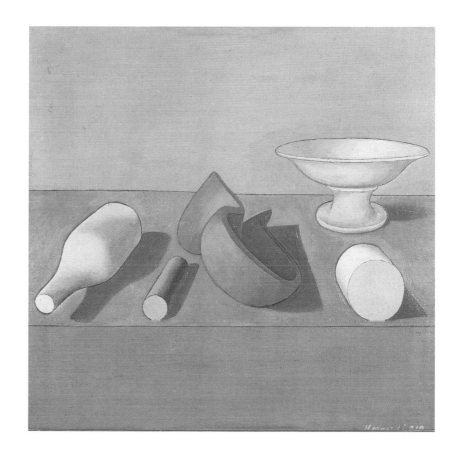

In the two recent table sculptures, the top of the rectangular object (the table's surface) is the same color as two of the sides signifying the space underneath. In *Table (Whatever)*, the robin's egg blue that designates the tabletop can be read as a void and a mirror of the sky, in addition to it being a hard, smooth surface. As a pictorial object, this table is made up of parts that fit seamlessly together, but our mind tells us that these are not the ones that should be there. I don't think of this as some kind of arty statement or even as a metaphor, but as an understanding of how individuals might understand their own life in time: it is all of a piece, but how and why these particular parts are the ones to have come together remains a mystery. That Artschwager should come to this sympathetic understanding of the individual's life at this point in time conveys the wisdom he brings to bear in his art.

The two table sculptures, along with the two *Splatter Chair* works (pages 37 and 39), which are made to be installed in the corner where two walls meet, establish a wide-ranging dialogue with the artist's recent paintings. *Lunch for One* (page 27) depicts two people, while *Lunch for Two* (page 29) portrays three; in each, a feeling of impending, unavoidable absence is evoked by the title, but not commented on in the image itself. There is not the smallest attempt to solicit the viewer's sympathy for a condition that we all inhabit. The paintings and the sculptures all invite the viewer to

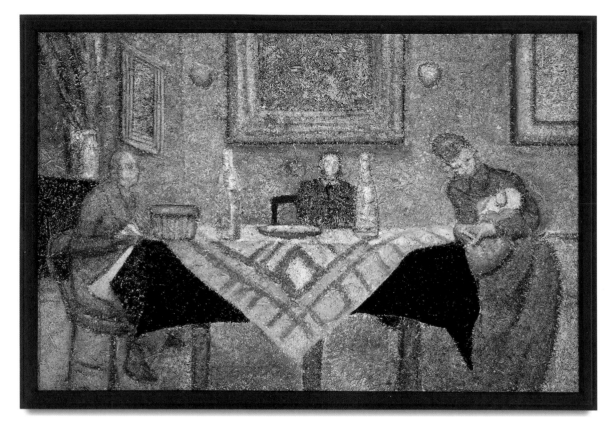

fig. 4
Richard Artschwager
Recollection (Vuillard)
2004
Acrylic on fiber panel
with artist's frame
51 x 74 inches
130 x 188 cm
Collection of Warren and Allison Kanders

construct a narrative, but it is one that reaches no conclusion—it exceeds the obvious and easily palatable one about the relationship between fact and fiction, the physical and the illusionistic, and goes on to ask difficult questions most of us try to ignore or suppress: How does the constantly changing proximity of sight and touch affect the way we live in the world and across time? How little or much of reality do we actually experience? What gets lost and what remains of any of us? To the latter question, Artschwager responds that what remains is art; one day, all the rest will be changed or absent.

In focusing on domestic interiors and café scenes, as he has in this recent body of work, Artschwager has consciously picked subjects that are considered central to artists. Pierre Bonnard, Édouard Vuillard, and Giorgio Morandi all celebrated domestic life and humble objects. It is a territory that is fraught with pitfalls, the most obvious being the temptation to be ironic or cynical about a world that seems increasingly remote. But Artschwager achieves the most difficult and least likely possibility of all; he makes it new, largely because of the bond he achieves between the charcoal (and sometimes the pastel) and the rough-surfaced handmade paper.

In *Berceuse* (page 15)—the title means "lullaby"—the artist depicts two people at a table, a bottle of wine between them. Their bodies and heads are tilted, as if they are inebriated. Is the artist thinking of a line from a children's round, rather than of a lullaby: "Merrily, merrily, merrily,

**Madame Hessel and Lulu in the
Dining-Room, Rue de Naples**
1936
Black crayon and gouache on
paper mounted on cardboard
37 x 47 inches
94 x 119 cm
Musée de Grenoble

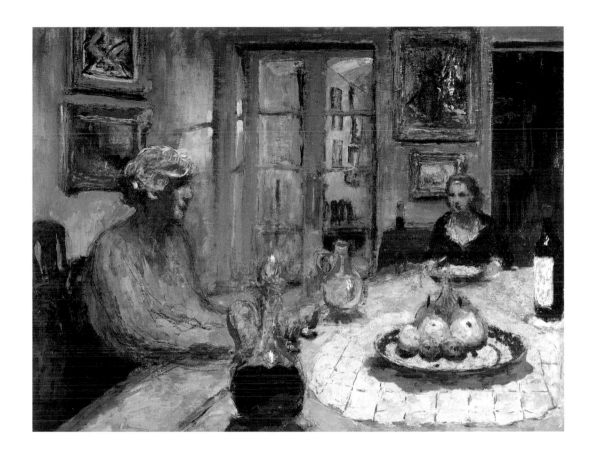

life is but a dream"? (How early the world teaches us that life is fleeting.) In *Landscape with Macadam* (page 33), he paints a row of trees alongside a two-lane highway, part of which can be seen curving along the bottom of the painting. As in his other recent paintings, the dominant colors are different tones of gray. This is not the neutral, rather cool gray that we know from his earlier work; it is warm and rather disquieting. The artist applies charcoal, in places suspended in a gel medium and in places not, to a surface that seems to be made of matted straw. The rough surface defies any attempt at draftsmanship, which is a particularly bold move for an artist whose body of drawings, including the large group collectively titled *Basket Table Door Window Mirror Rug* (1974), constitutes a singular achievement in postwar art. The trees are both ashen and tinged with soft, beckoning light. It's as if they have been bathed in volcanic ash and exist in a state of erasure. Might we not see these scenes as precise indicators of memory? In our mind's eye, we see the past both clearly and fuzzily.

With their disconcerting perspectives, internal shifts in scale, and compressions of space, one is tempted to say that these paintings convey a dreamlike state, but that offers a way out, and that is not what Artschwager is after. In *Lunch for One*, a man whose face is both blurred and rubbed out sits on a set of stairs, facing a woman seated at an oval table. The stairs culminate

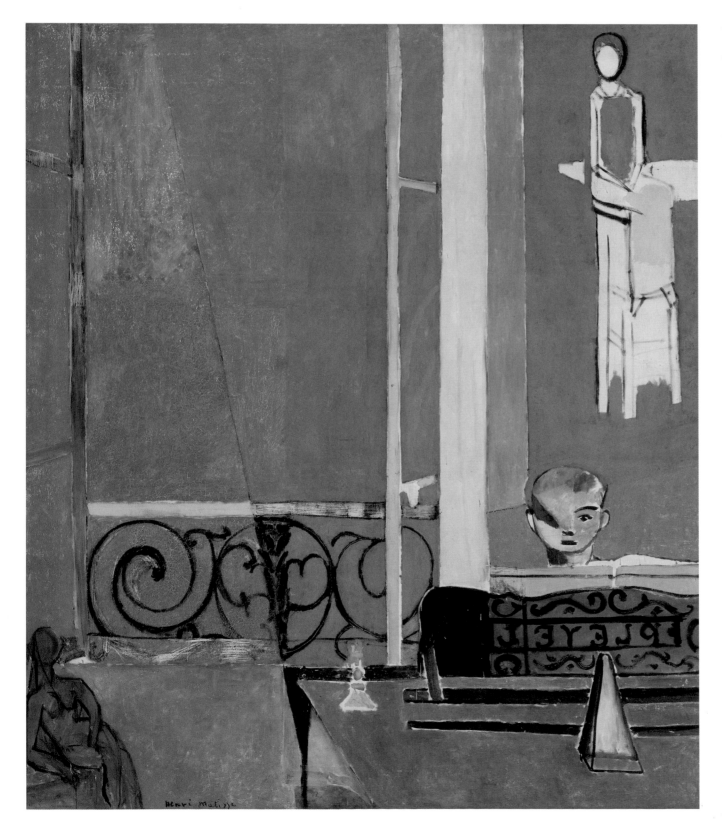

fig. 6
Henri Matisse
The Piano Lesson
1916
Oil on canvas
96 ½ x 83 ¼ inches
245 x 213 cm
The Museum of Modern Art, New York

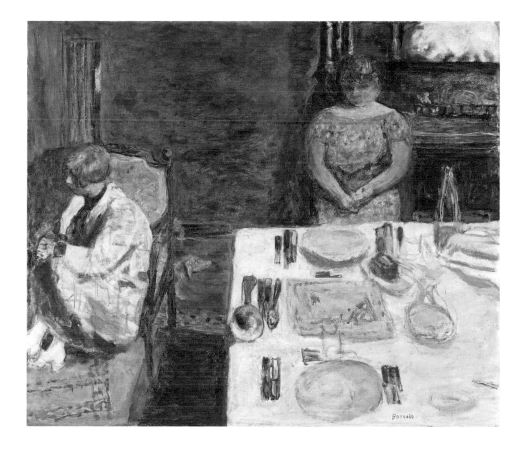

in what looks like a stage curtain. Behind the woman is a painting of a table very much like the one in front of her, and on the table are plates whose outlines echo the tables'. The woman's head is cropped by the bottom edge of the painting-within-the-painting, and this positions her in two places at once, the room and the painting. Not only is this work unsettling, but it never sinks into an explicit narrative. Is the man a memory, a ghost, or an unwanted visitor? We look in order to know, but we cannot know even as we keep looking. Isn't this conundrum central to our existence?

Artschwager has had a long and productive dialogue with the work of the American Magic Realist painter George Tooker. In contrast to Tooker, however, he has never settled for visual literalness in his depictions of modern alienation. The fact that he could have gotten something from Tooker, along with the more obvious sources of Vuillard, Bonnard, and Morandi, in his recent works is further evidence of his independent thinking and analysis. However, as should now be evident, his paintings are neither pastiches nor ironic commentaries, but a complete transformation of what has become a cliché in the work of so many other artists. It's as if Artschwager is updating the viewer on how the people seen in these earlier artists' paintings would look now, some fifty to one hundred years later. That he does so without devolving into morbidity is one of the stunning achievements of his recent work.

In *Lunch for Two*, two people are seated at a table, facing each other. In the distance of this weirdly sized room, a man sits playing a piano, his back to the pair. Does it help to know that the artist plays the piano? The two paintings of animals depicted on either side of the piano, each of which hangs above the head of one of the individuals at the table—what do these mean? Or the fact that they, too, are facing each other, like their human counterparts? All the paintings are replete with questions, none of which can be reduced to a single answer. The scenes are domestic and haunted. The gray seems be made of ash (which it is), stone, and foggy light. It's as if everything is in a state of petrifaction. The fact that the paintings invite the viewer to touch them makes them all the more powerful, for how do we begin to recognize and understand death unless we come close and touch it?

There is not an ounce of sentimentality in these recent paintings and sculptures. Given the art world's keenness for kitsch, for hyped statements regarding spirituality and transcendence, smug reiterations of received tropes, and self-righteous political art, Artschwager's acts of freedom—from sentimentality and art world agendas—are invaluable for what they tell us about art and life. Willing to utilize the most unlikely of materials, he has remained curious about reality, as well as determined to keep gazing at daily life, which he knows is pulling him forward.

Notes

1. The title is taken from Artschwager's introduction to a catalogue of the painter Robert Stanley's work; see "Parade in the Face of Death," reprinted in *Richard Artschwager: Texts and Interviews*, ed. Dieter Schwartz (Düsseldorf: Richter Verlag; Winterthur, Switzerland: Kunstmuseum Winterthur, 2003), p. 109.

2. Artschwager, "Malcolm Morley," in *Richard Artschwager: Texts and Interviews*, p. 118.

3. "Questions to Stella and Judd," ed. Lucy Lippard, *ARTnews*, vol. 65, no. 5 (Sept. 1966), pp. 55-61.

4. "Four Sentences for *Art in America*," *Art in America*, vol. 53, no. 5 (Oct.–Nov. 1965); reprinted in *Richard Artschwager: Texts and Interviews*, p. 14.

Plates

Berceuse
2007
Charcoal, acrylic, and laminate on
handmade paper on soundboard
with artist's frame
75 x 48 inches
191 x 122 cm

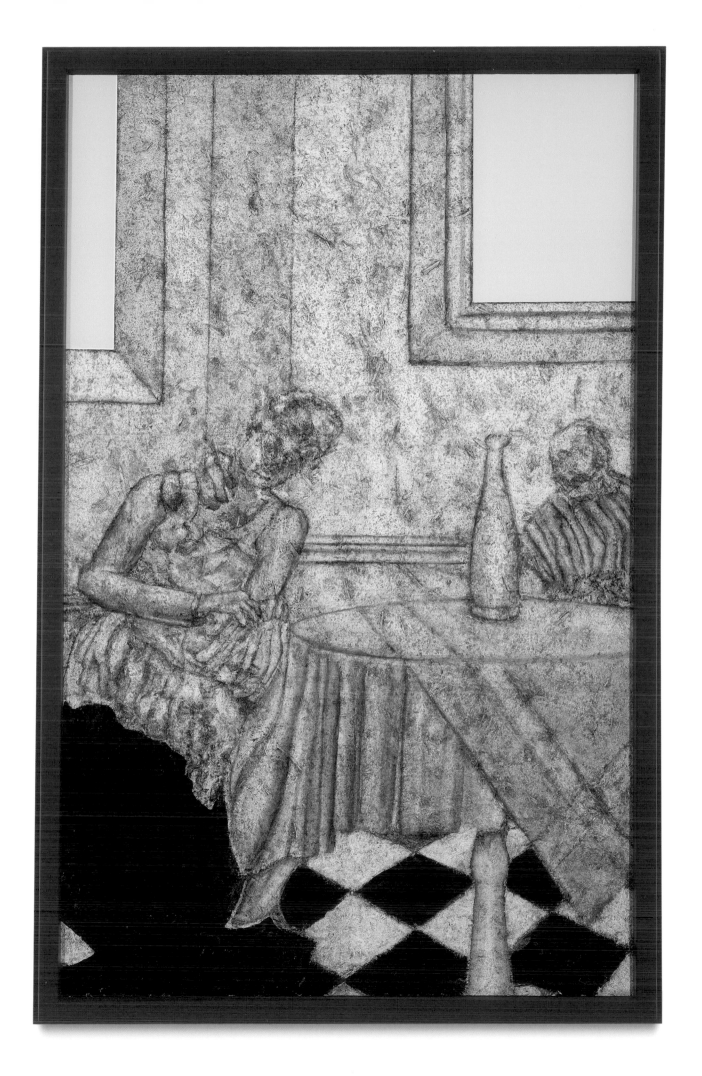

Late Lunch
2007
Charcoal, acrylic, and laminate on
handmade paper on soundboard
with artist's frame
75 ¼ x 51 inches
191 x 130 cm

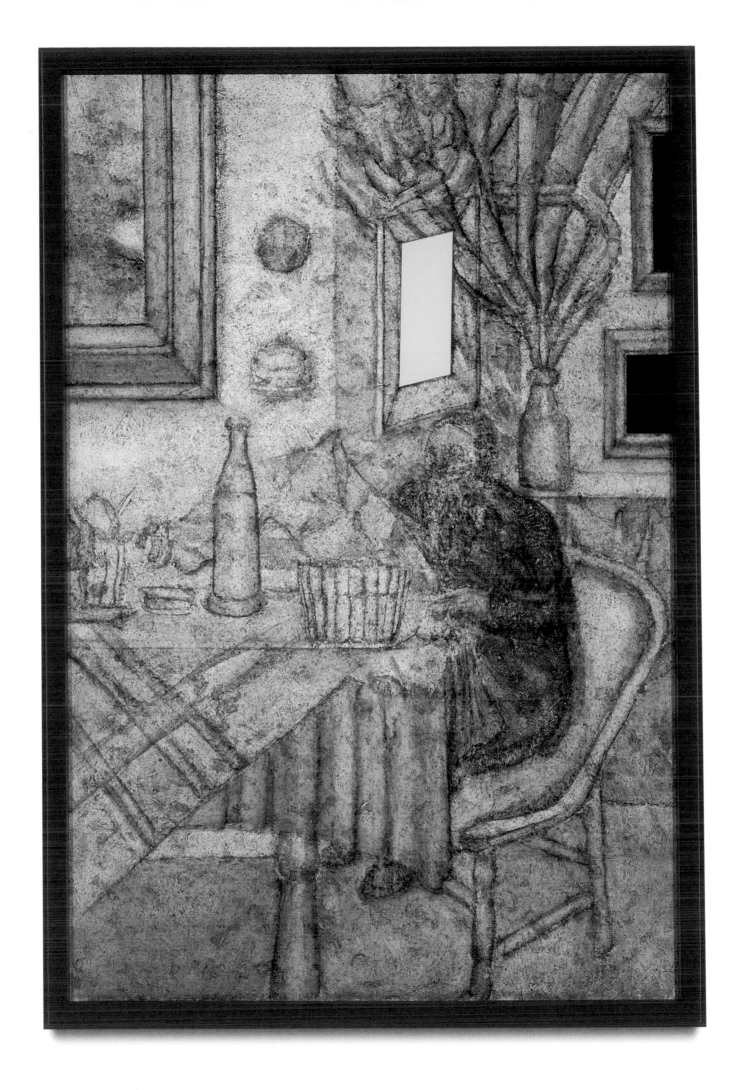

Grandmother in Chair
2007
Charcoal and acrylic on
handmade paper on soundboard
with artist's frame
52 x 69 ½ inches
132 x 177 cm

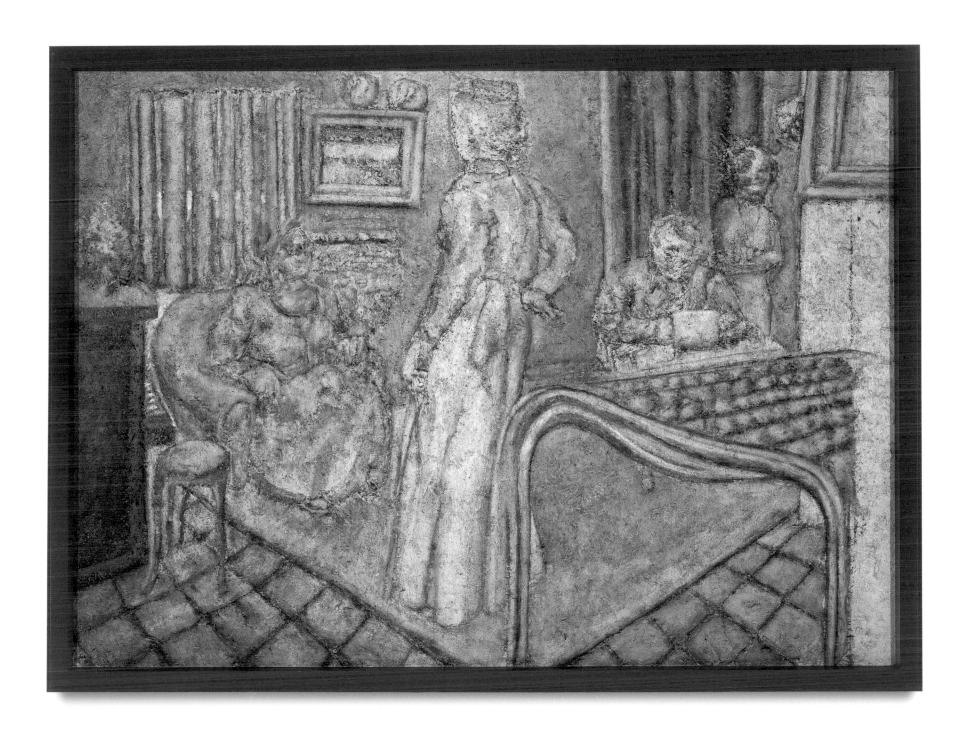

Woman with Cat
2007
Charcoal and acrylic on
handmade paper on soundboard
with artist's frame
48 x 51 inches
122 x 130 cm

Alter Ego
2007
Charcoal, pastel, and acrylic on
handmade paper on soundboard
with artist's frame
50 x 76 inches
127 x 193 cm

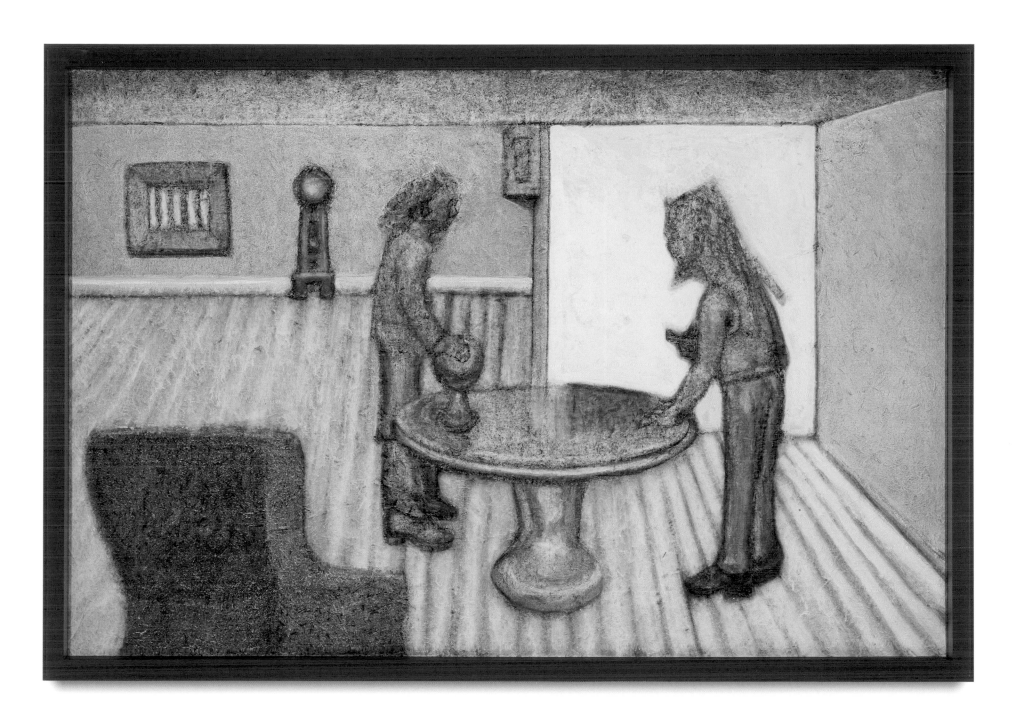

Two Clocks
2007
Charcoal and acrylic on
handmade paper on soundboard
with artist's frame
51 ¾ x 76 ¼ inches
131 x 194 cm

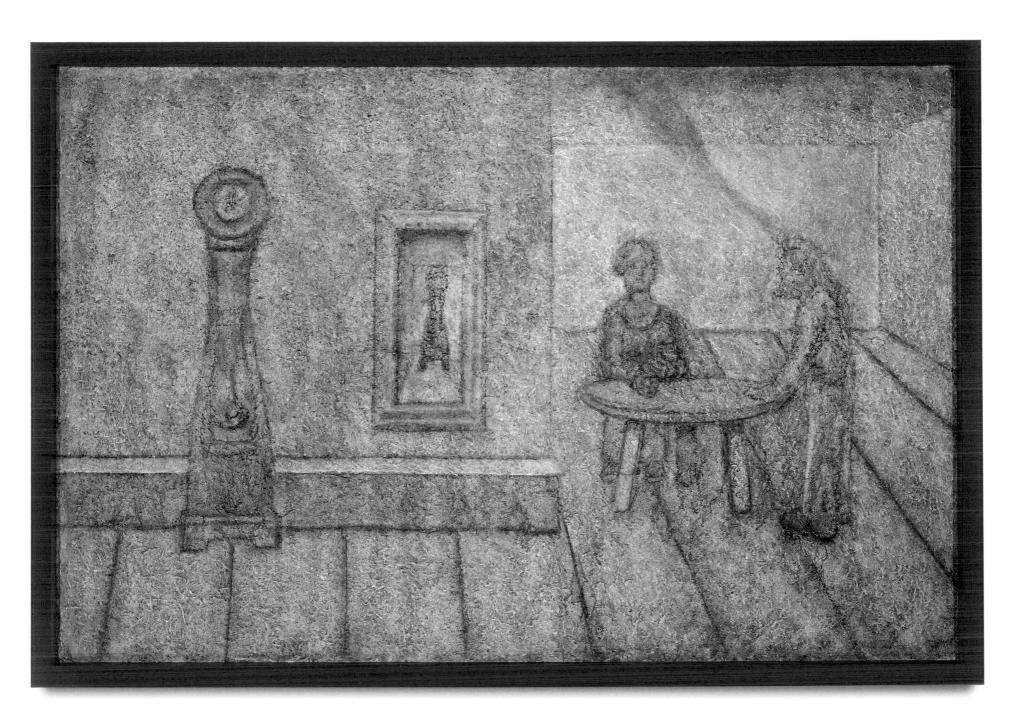

Lunch for One
2007
Charcoal, acrylic, and laminate on
handmade paper on soundboard
with artist's frame
50 x 74 inches
127 x 188 cm

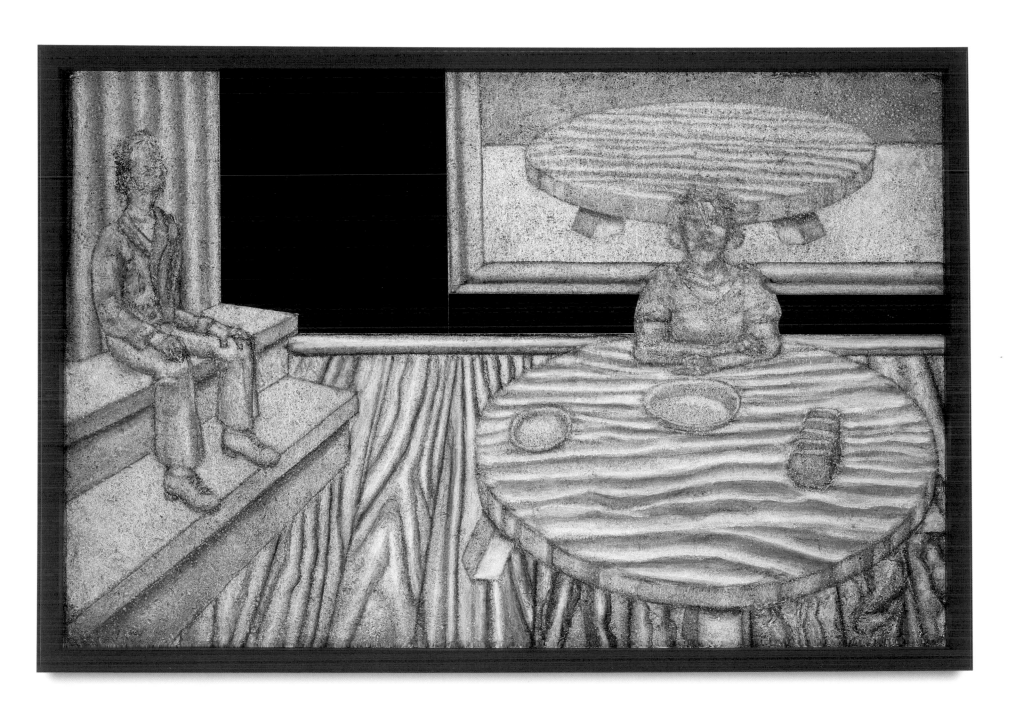

Lunch for Two
2007
Charcoal, acrylic, and laminate on
handmade paper on soundboard
with artist's frame
51 ½ x 75 ½ inches
131 x 192 cm

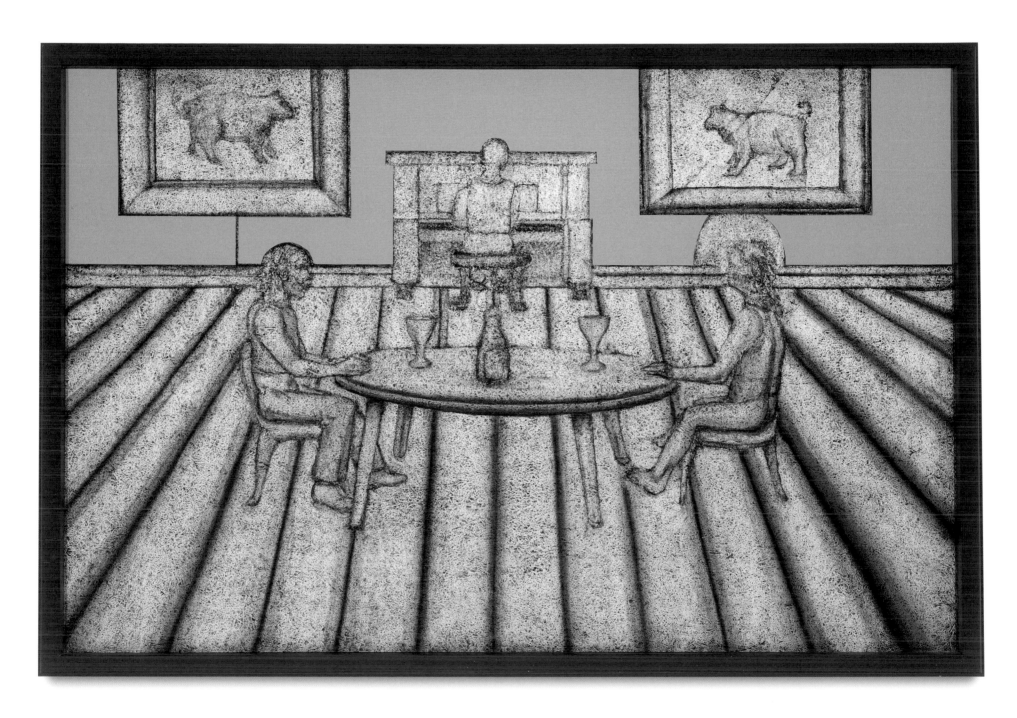

Light Bulbs
2007
Charcoal, pastel, and acrylic on
handmade paper on soundboard
with artist's frame
52 x 75 ½ inches
132 x 192 cm

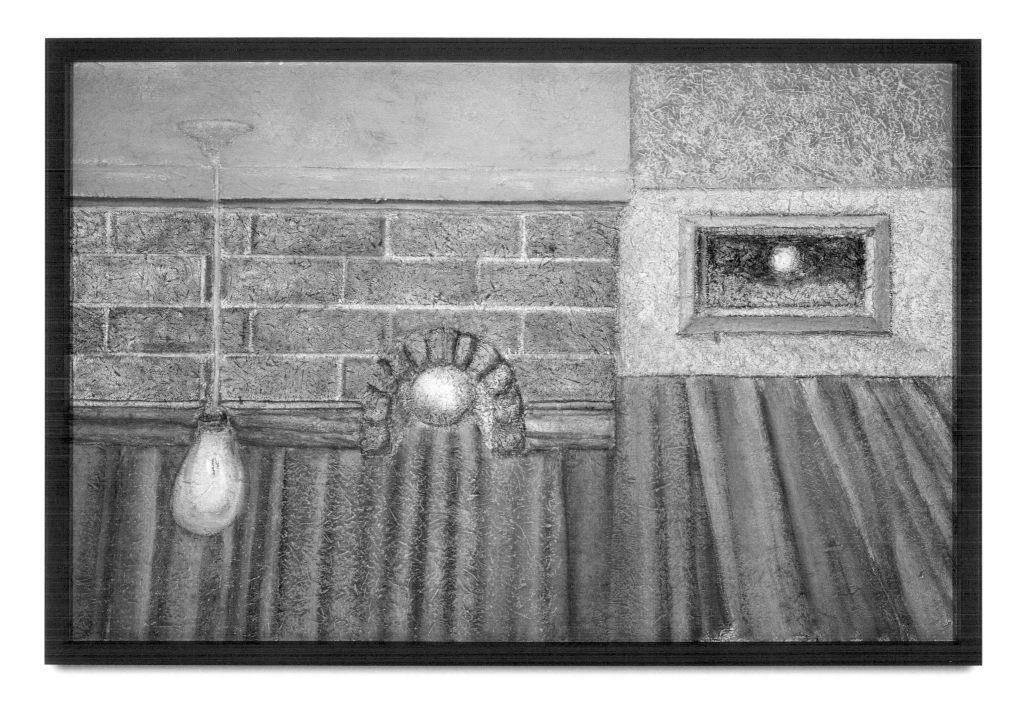

Landscape with Macadam
2007
Charcoal and acrylic on
handmade paper on soundboard
with artist's painted frame
56 x 81 inches
142 x 206 cm

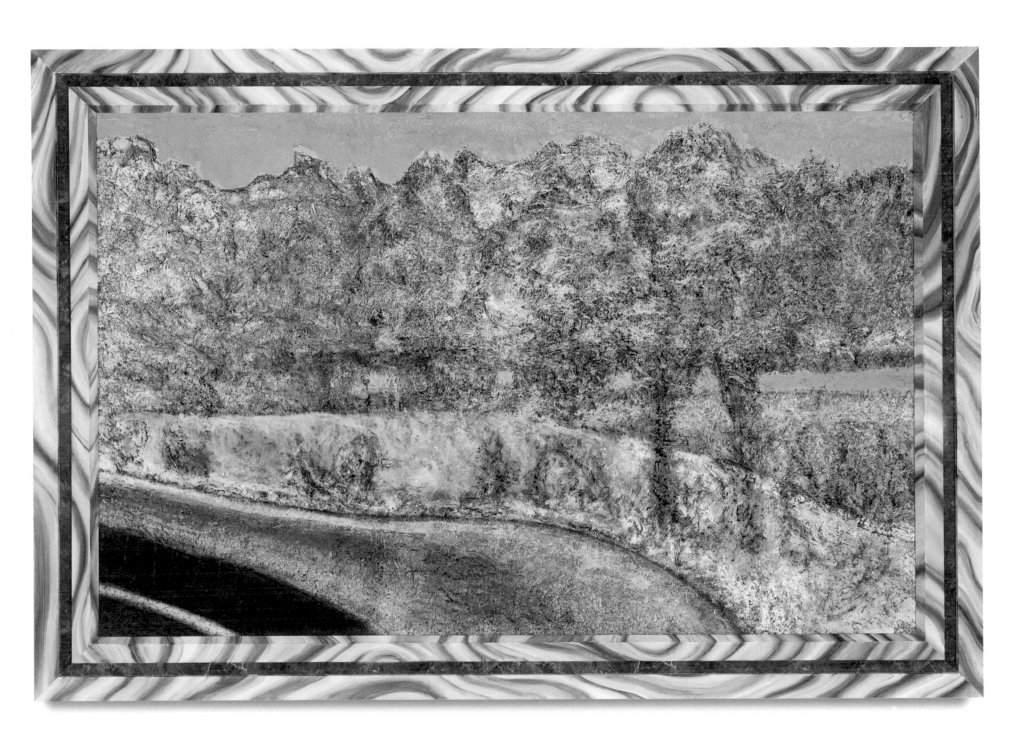

Bigger than Morandi
2007
Charcoal, pastel, and acrylic on
handmade paper on soundboard
with artist's frame
75¾ x 52 inches
192 x 132 cm

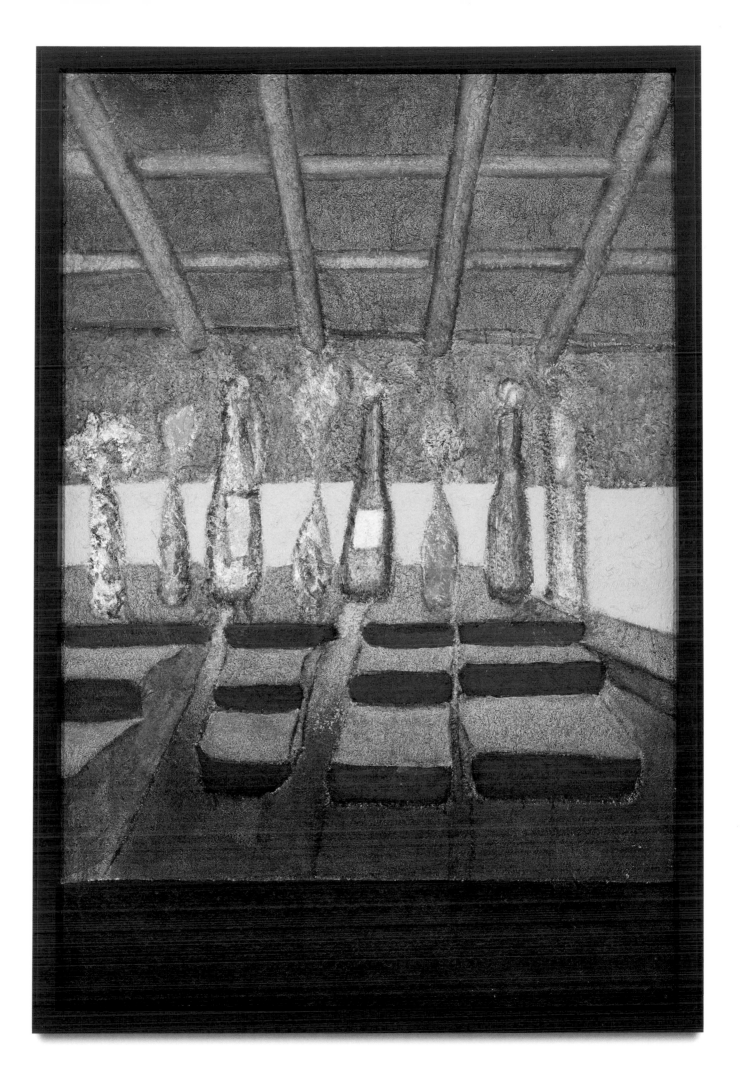

Splatter Chair A
2008
Formica on wood, in two parts
Left: 57 x 40 ½ inches
145 x 103 cm
Right: 61 x 34 inches
155 x 86 cm

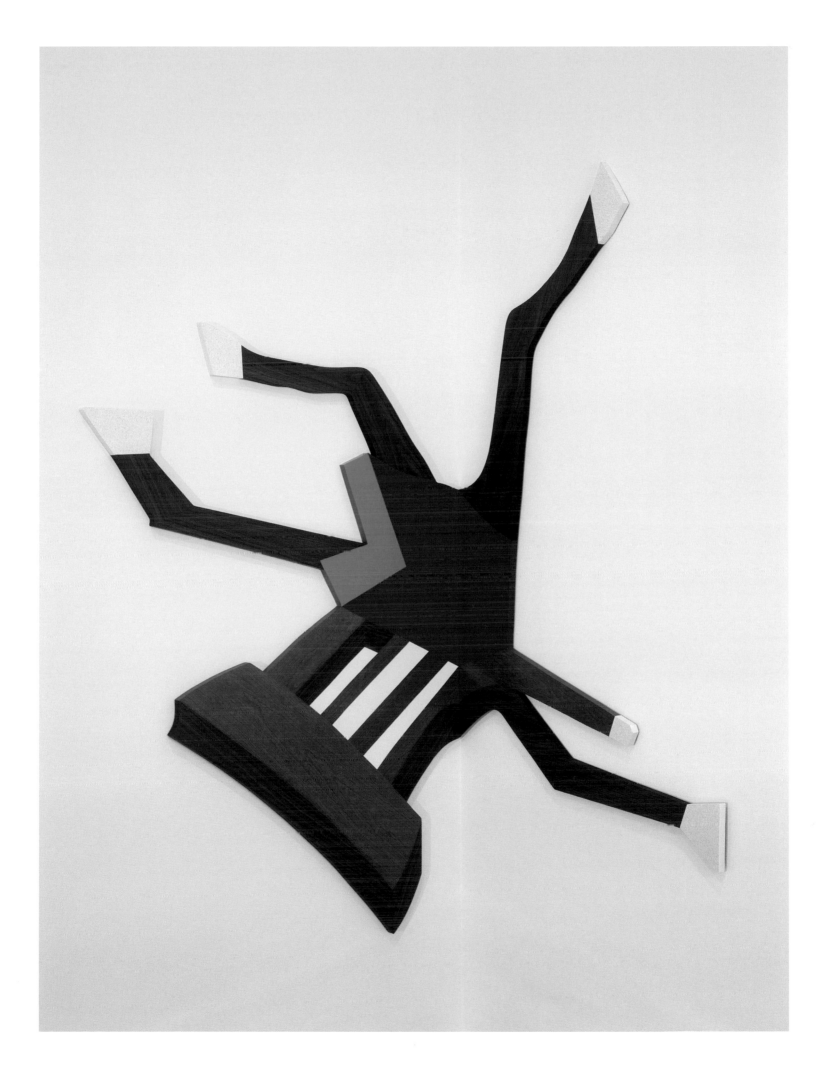

Splatter Chair B
2008
Formica and acrylic on wood,
in four parts
Left (three parts): 17 ¼ x 6 ¼ inches
44 x 16 cm
27 x 26 ¾ inches
69 x 68 cm
9 x 3 ½ inches
23 x 9 cm
Right (one part): 52 ¼ x 28 ½ inches
133 x 72 cm

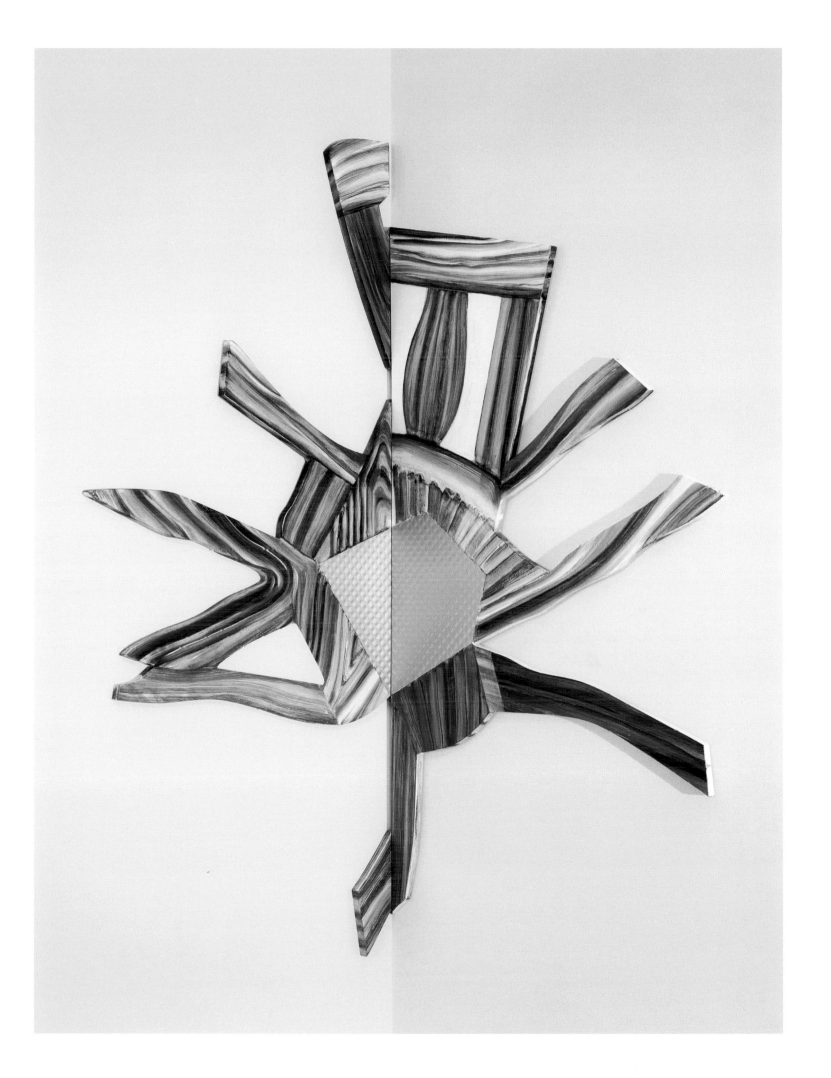

Table (Whatever)
2007
Laminate on wood
30 x 53 x 48 inches
76 x 135 x 122 cm

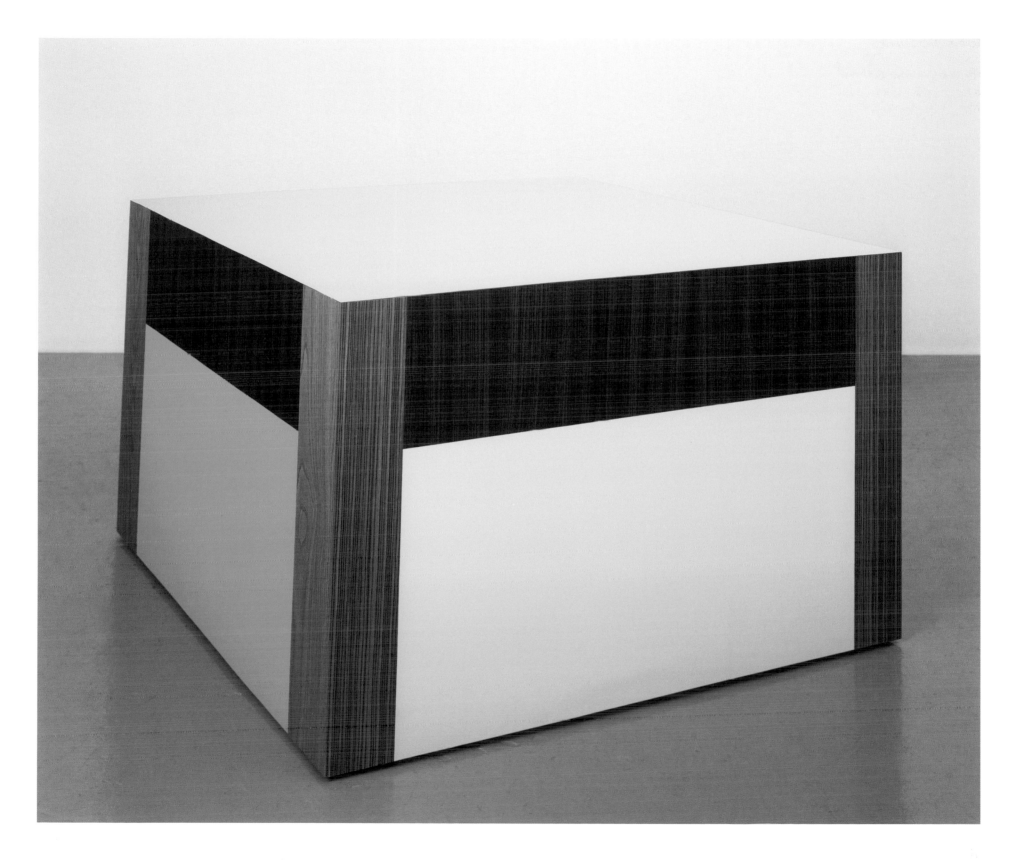

Table (Somewhat)
2007
Laminate on wood
30 x 52 x 43 ½ inches
76 x 132 x 110 cm

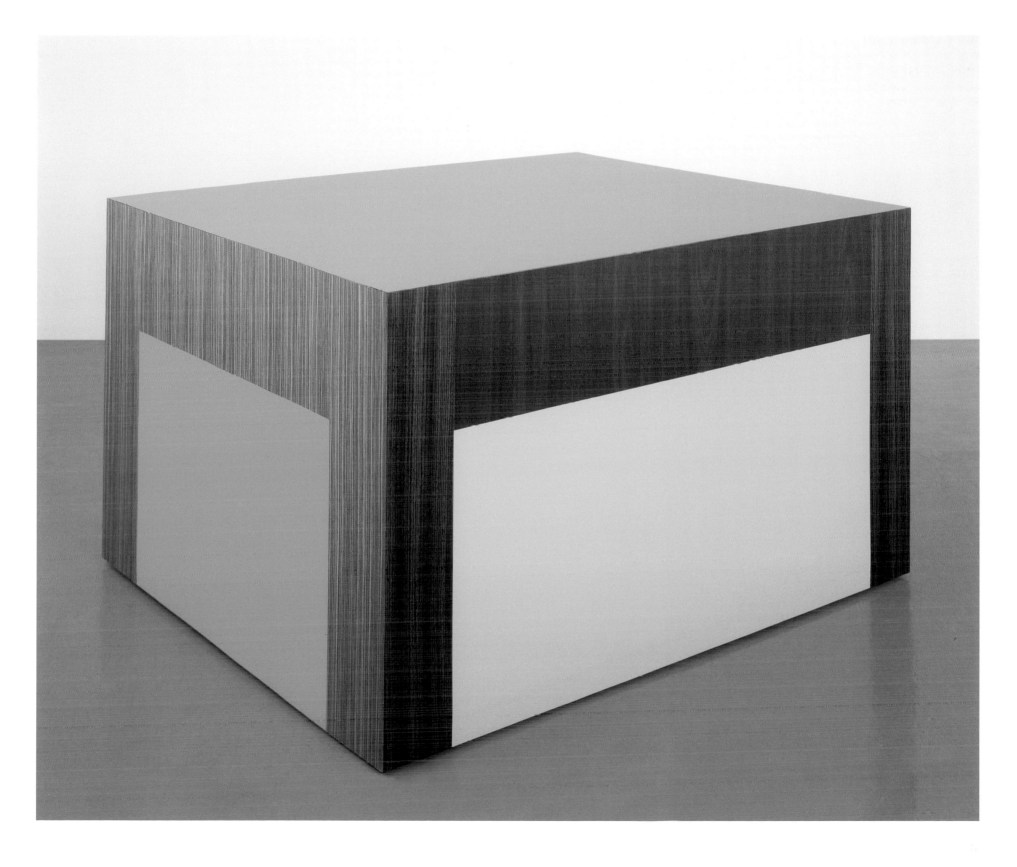

Exclamation Point (Turquoise)
2008
Plastic bristles, mahogany,
and latex
61 x 19 x 19 inches
155 x 48 x 48 cm

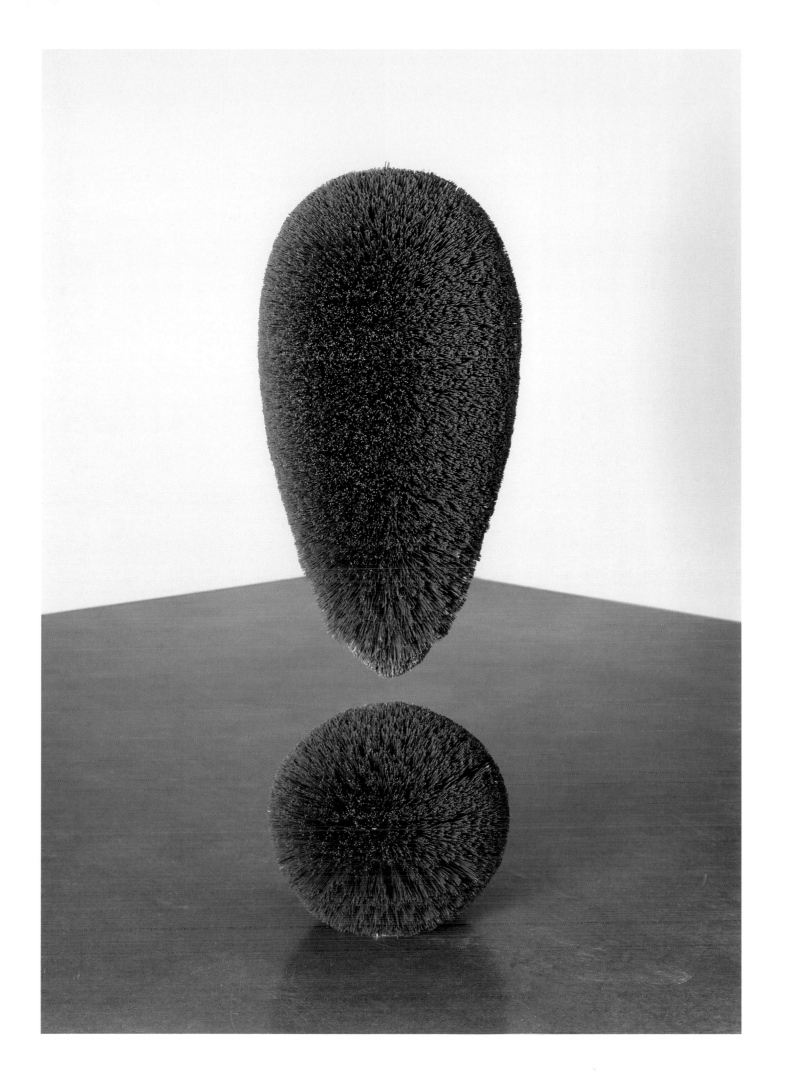

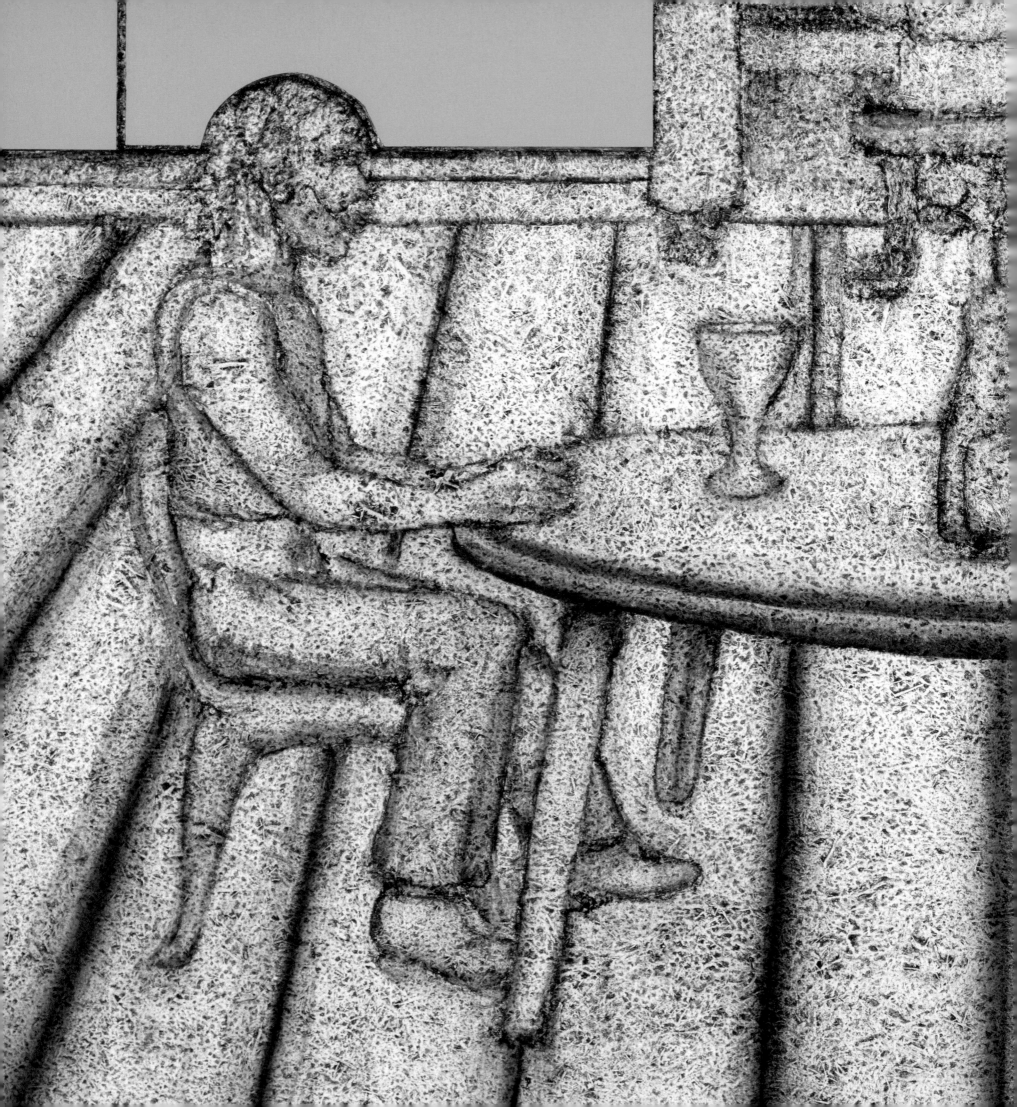

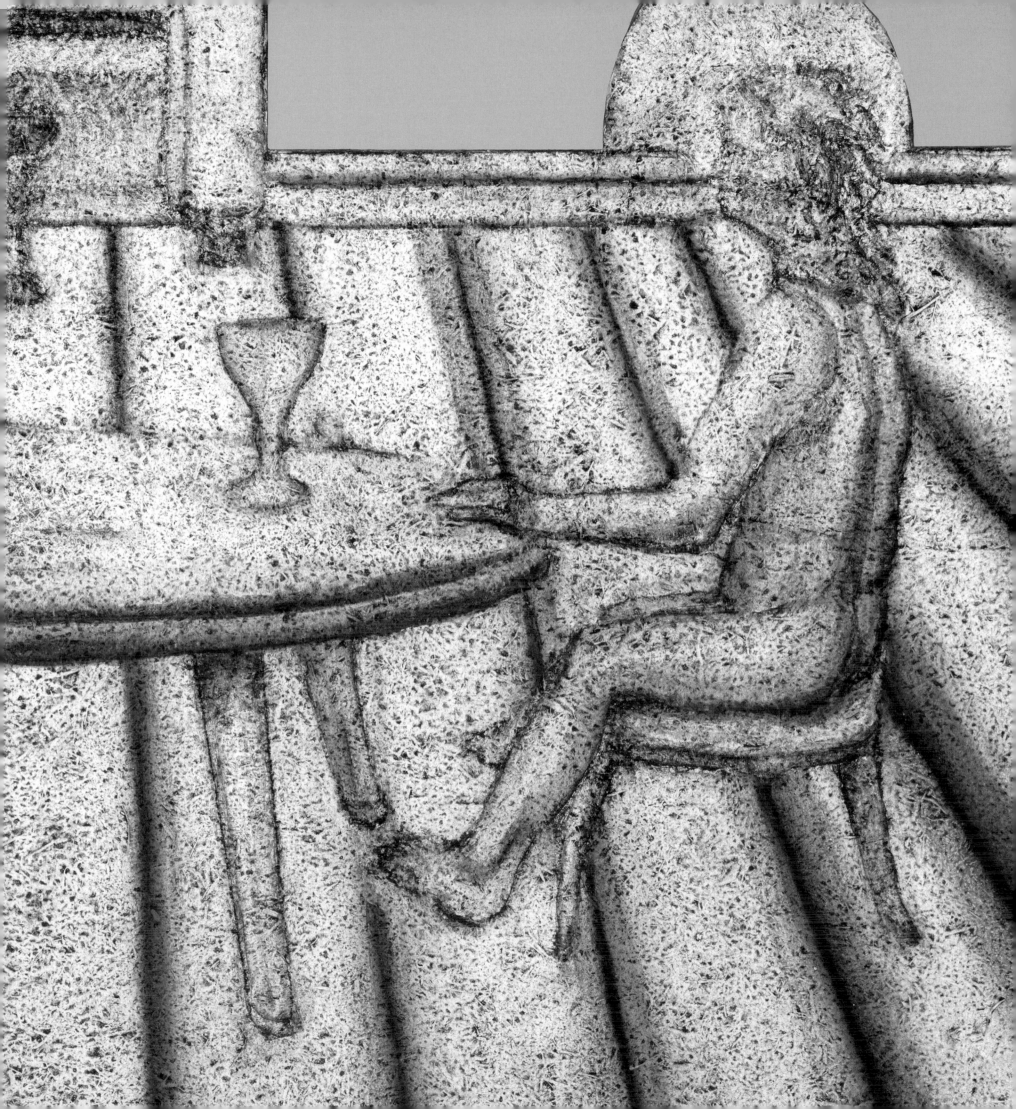

Installation

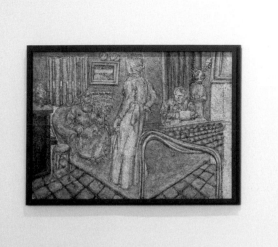
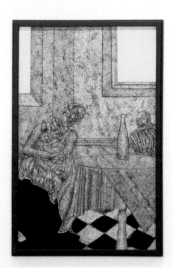
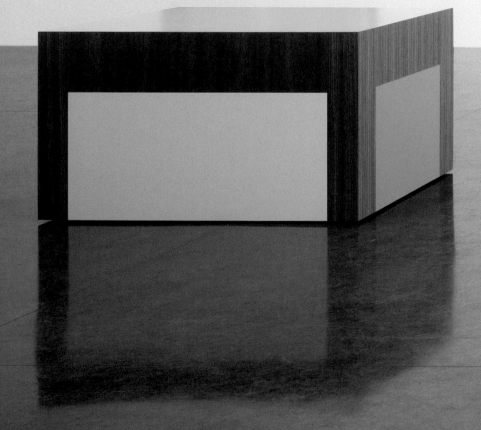

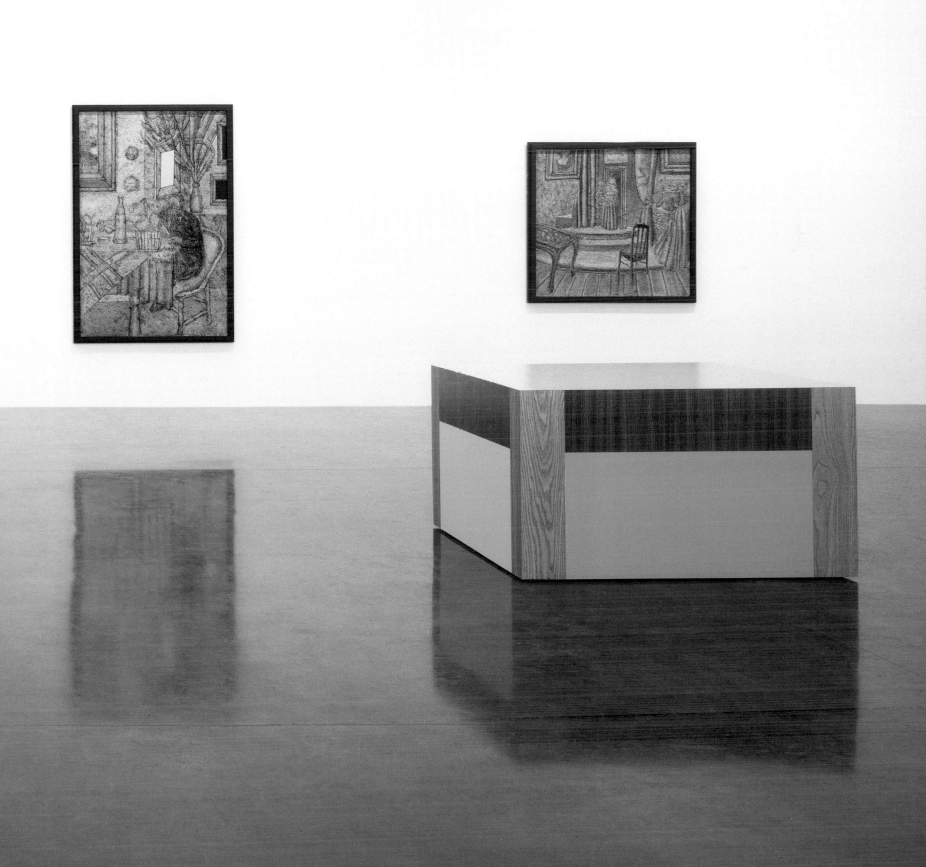

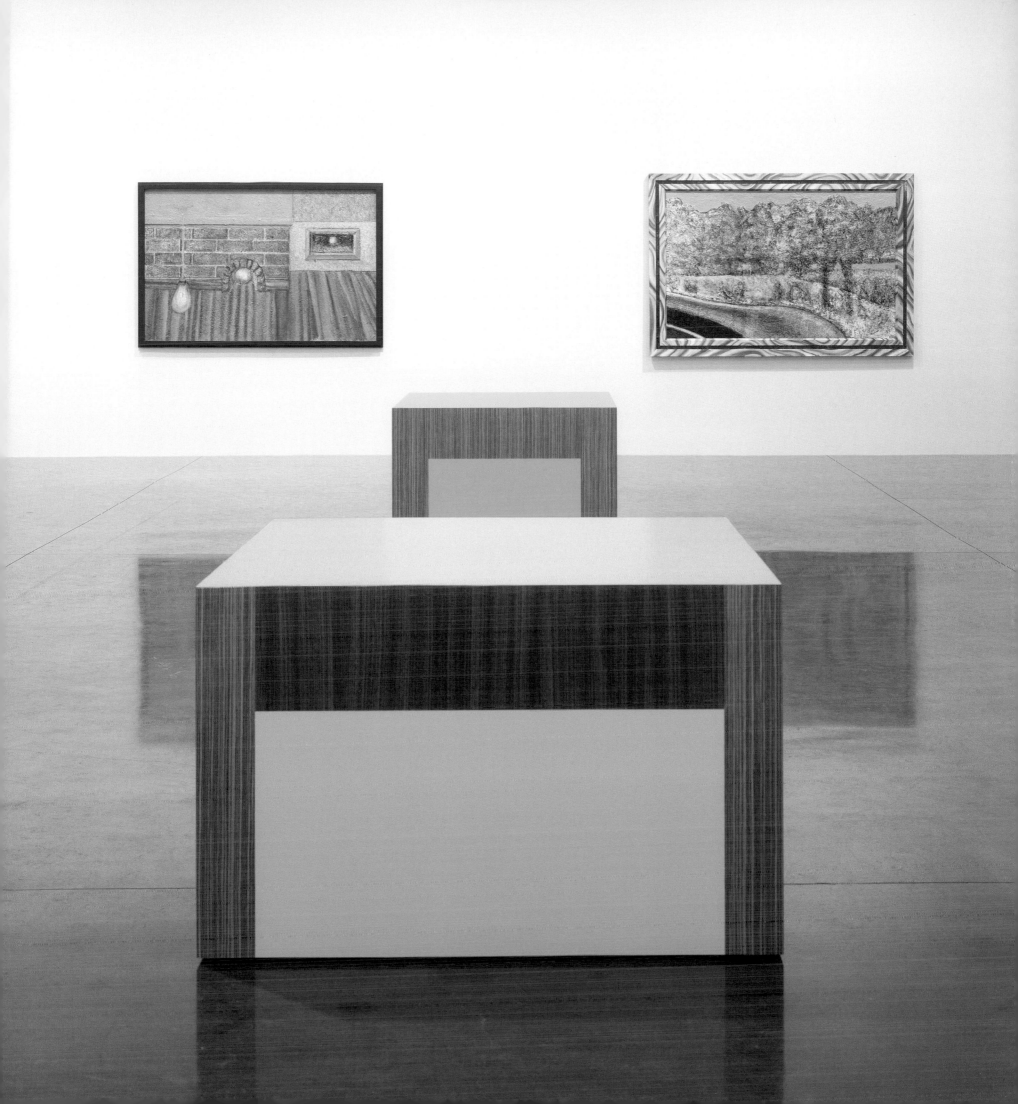

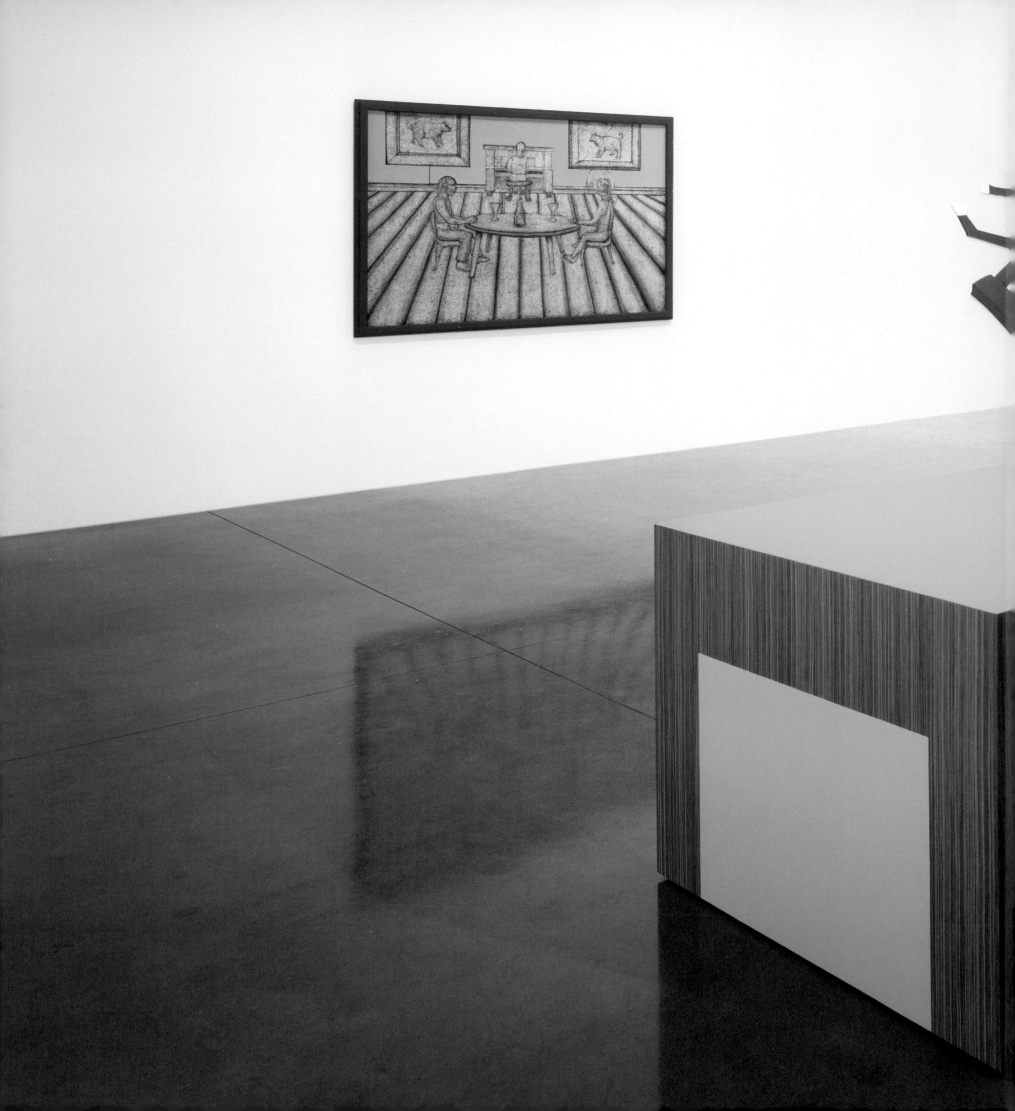

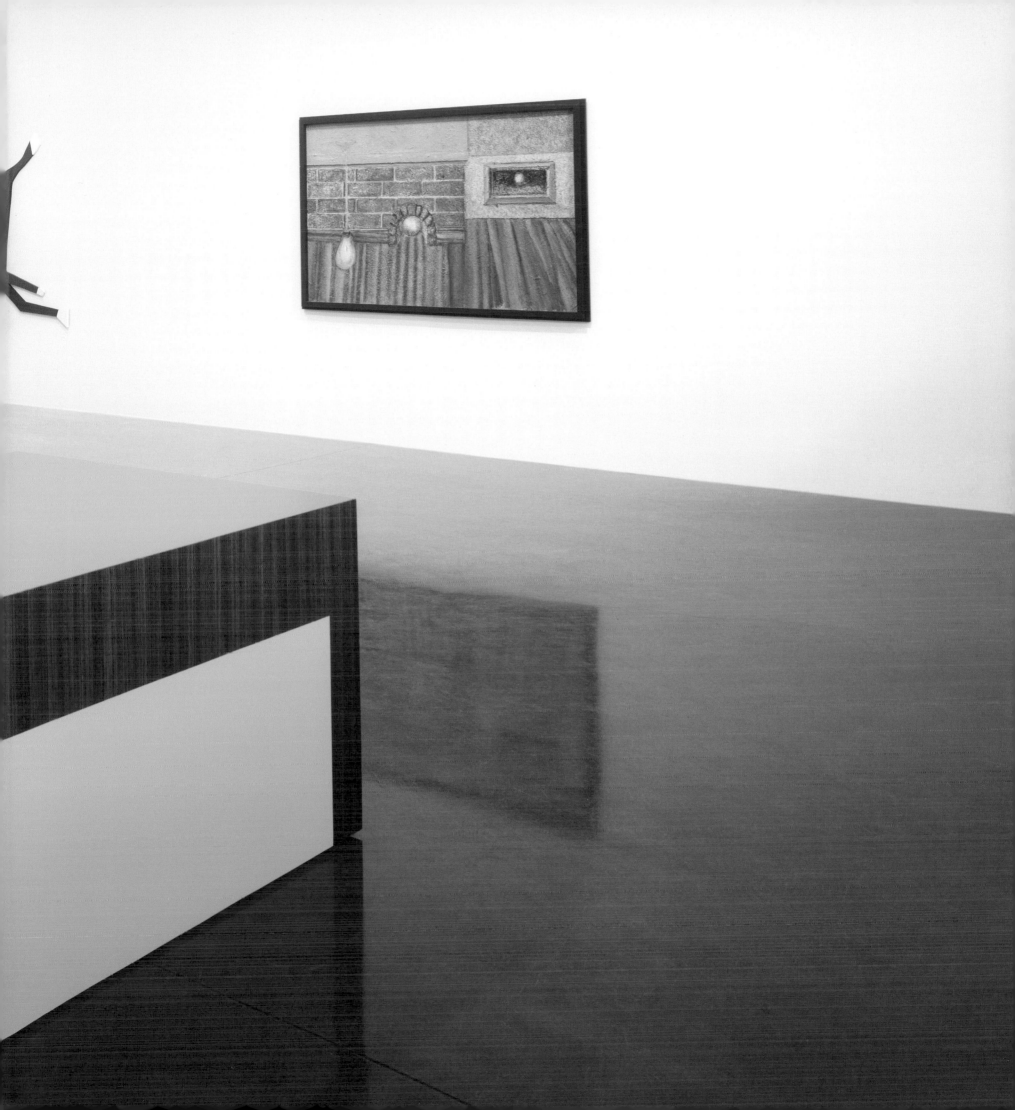

Published on the occasion of the exhibition

RICHARD ARTSCHWAGER

January 24 – March 1, 2008

Gagosian Gallery
555 West 24th Street
New York, NY 10011
T. 212.741.1111
www.gagosian.com

Publication © 2008 Gagosian Gallery
A Connoisseur of Absurdities © John Yau

Editor: Bob Monk
Managing editor: Alison McDonald

Gagosian Gallery coordinators: Justin Adian, Darlina Goldak,
Nicole Heck, Richie Lasansky, Melissa Lazarov, Rob McKeever,
Michelle Pobar, and Allison Smith

Copy editor: Jennifer Knox White

Design by Takaya Goto and Lesley Chi, Goto Design, New York
Color separations by Echelon, Venice, CA
Printed by Shapco Printing, Minneapolis, MN

ISBN # 1-932598-66-9